IMAGES *of* SOUND

NINA LEEN

all photographs by the author

W · W · NORTON & COMPANY, INC · NEW YORK

Also by Nina Leen

Women, Heroes, and a Frog
Love, Sunrise, and Elevated Apes

Lines from *The Fog Horn* copyright 1953 by Ray Bradbury, reprinted by
permission of Harold Matson Co., Inc.

Lines from *The Santa Fe Trail* from *Collected Poems* by Vachel
Lindsay are reprinted with permission of Macmillan Publishing
Co., Inc. Copyright 1914 by Macmillan Publishing Co., Inc.,
renewed 1942 by Elizabeth C. Lindsay.

Layout by the Author

Library of Congress Cataloging in Publication Data
Leen, Nina, 1909-
Images of sound.

 1. Photography, Artistic. I. Title.
TR654.L42 1977 779′.092′4 77-9438
ISBN 0-393-08795-6
ISBN 0-393-08800-6 pbk.

1 2 3 4 5 6 7 8 9 0

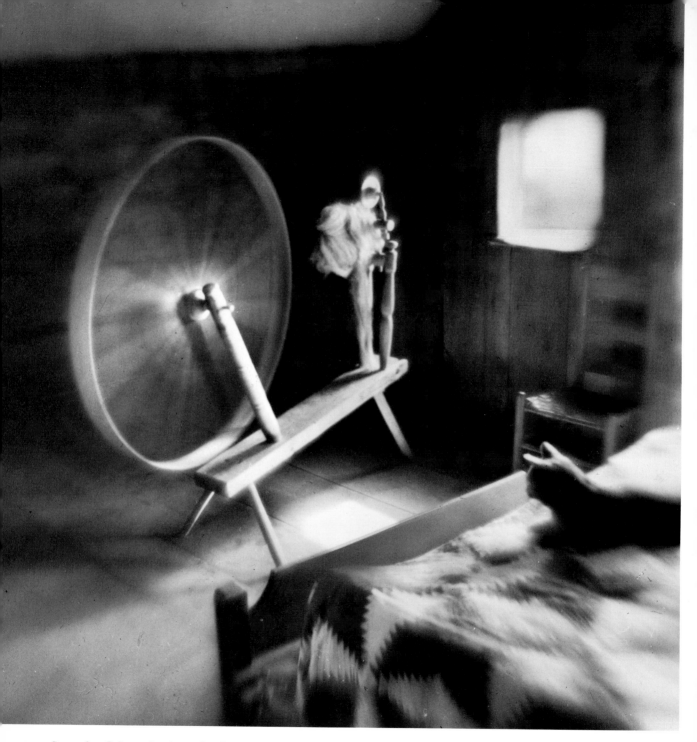

Sounds of the spinning wheel turning have often been heard coming from the attic... and there is a certain high, sustained musical note that vibrates now and then by day, as well as by night.

James Lincoln Huntington
at the Bishop Huntington House in New England

"What comes with a carriage
and goes with a carriage,
is of no use to the carriage,
and yet the carriage cannot
move without it?"—"A noise."

Old riddle

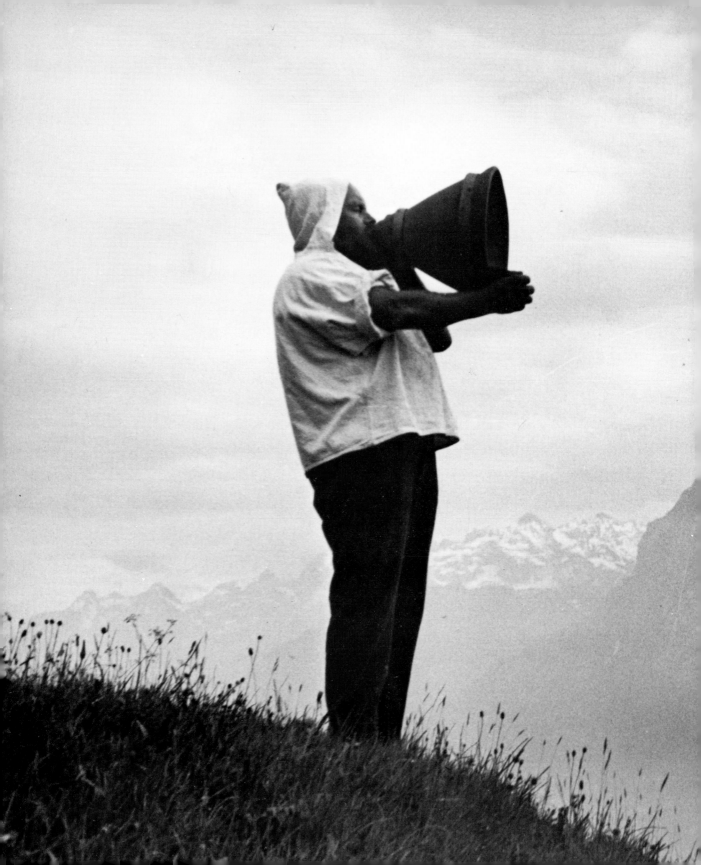

The mingled notes came softened from below.
Oliver Goldsmith (1728–1774)

The hell of waters!
Where they howl and hiss,
and boil in endless torture.
Lord Byron (1788–1824)

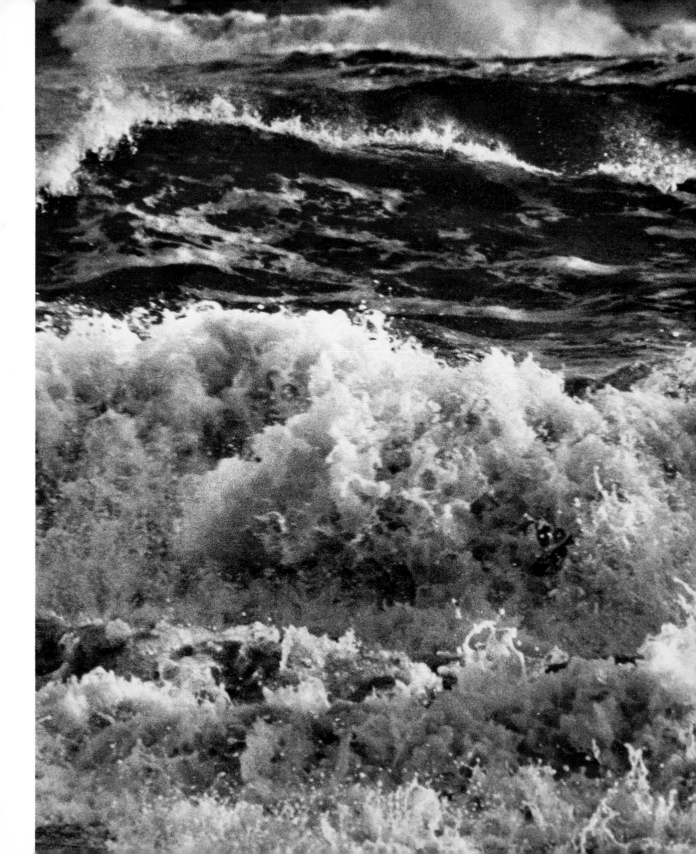

Gather a shell from the strown beach
And listen at its lips: they sigh
The same desire and mystery,
The echo of the whole sea's speech.
Dante Gabriel Rossetti (1828–1882)

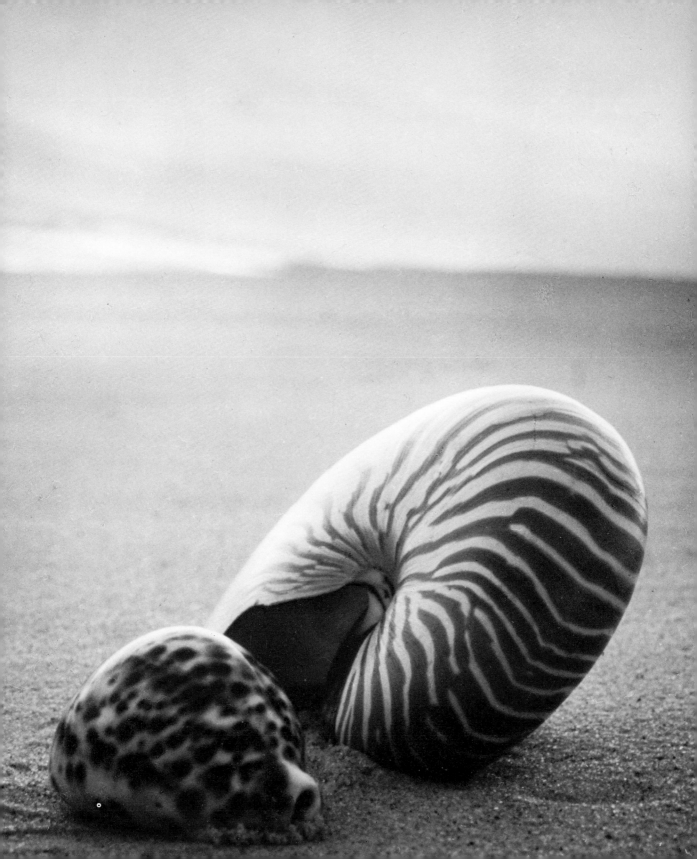

We can heat the body, we can cool it;
we can give it tension or relaxation;
and surely it is possible to bring it
into a state in which rising from bed
will not be a pain.

James Boswell (1740–1795)

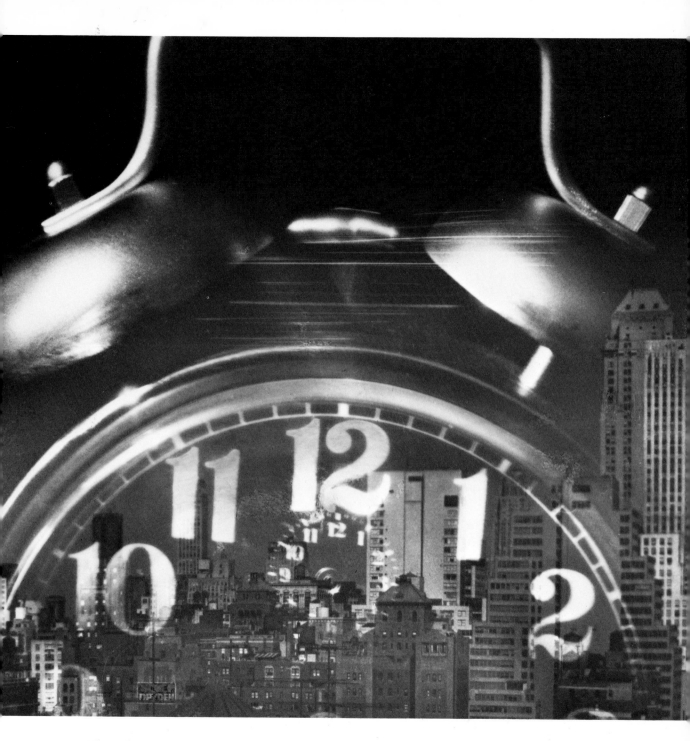

There is not a single proverb in favor of early rising that appeals to the higher nature of man.

Robert Lynd (1879–1949)

An ounce of work is worth many pounds of words.

Saint Francis de Sales (1567–1622)

In art it is not thinking that does the job,
but making.

Johann Wolfgang von Goethe (1749–1832)

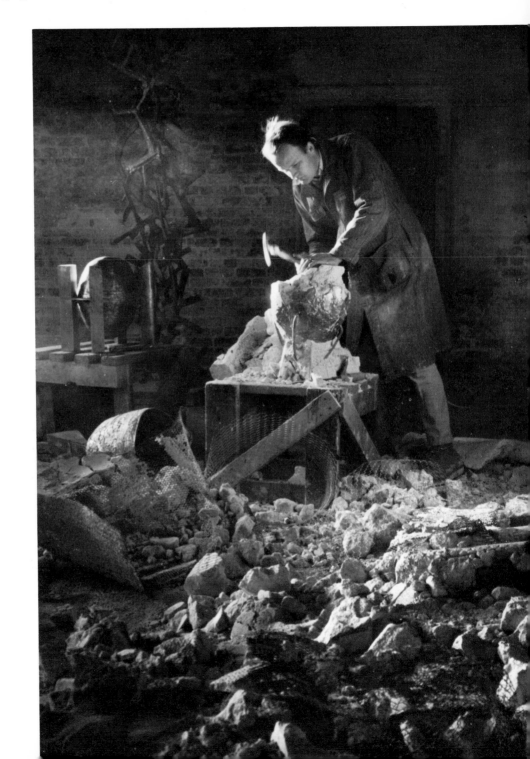

And learn, my sons, the wondrous power of NOISE.
Alexander Pope (1688–1744)

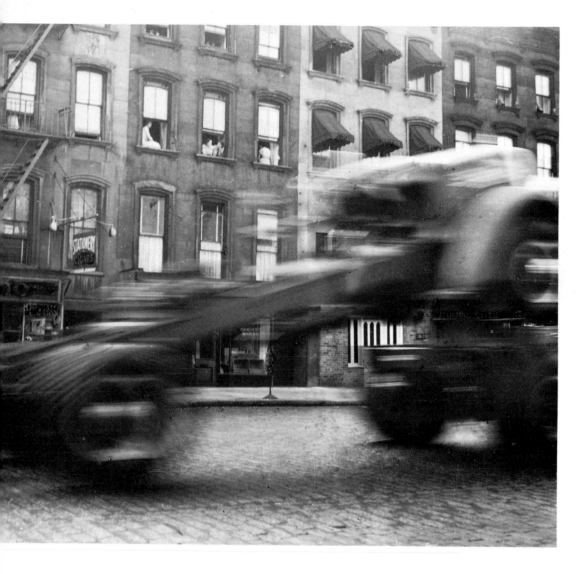

Noise...
The chief product and authenticating sign of civilisation.

Ambrose Bierce (1842–1914)

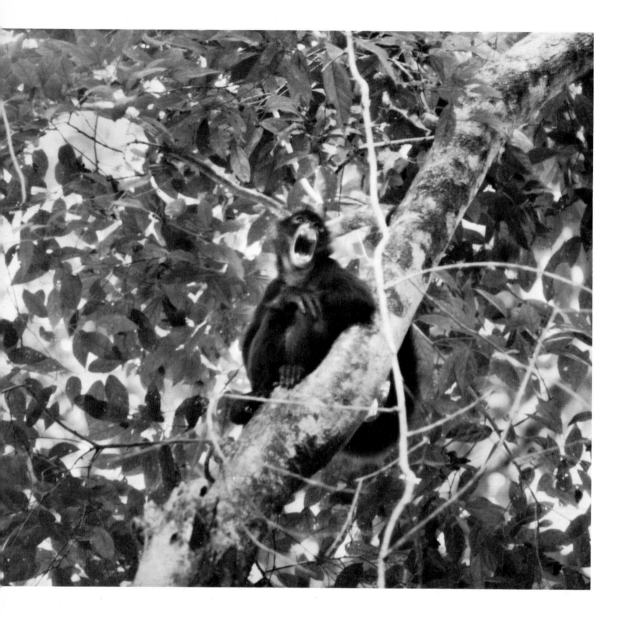

No sound is dissonant which tells of life.

Samuel Taylor Coleridge (1772–1834)

...street music; a music which sounds like the actual voice of the human Heart, singing the lost joys, the regrets, the loveless lives of the people who blacken the pavements.

Logan Pearsall Smith (1865–1946)

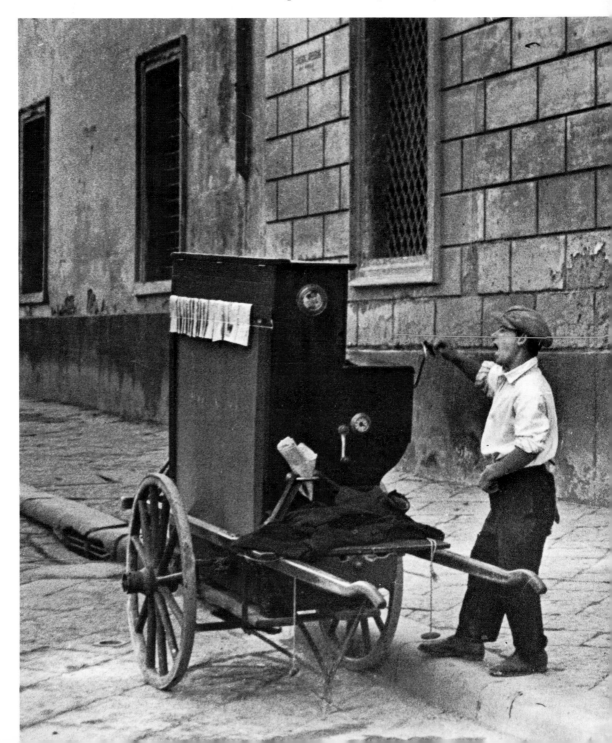

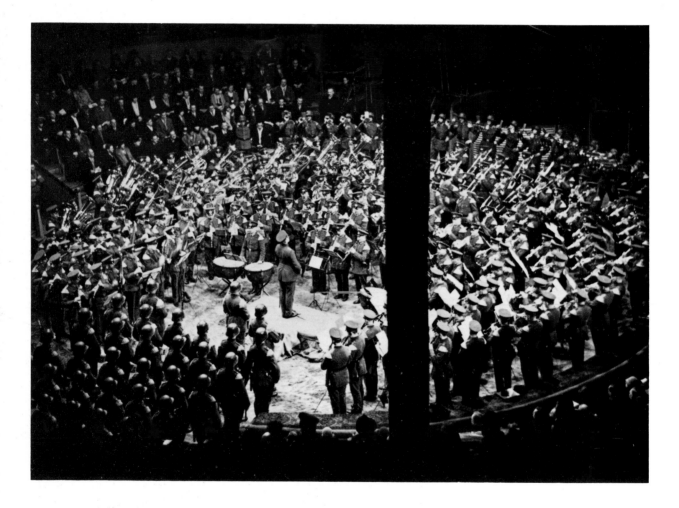

We all have a skin that is sensitive to
...military marches.

Jean Cocteau (1889–1963)

Sonorous metal blowing
martial sounds.

John Milton (1608–1674)

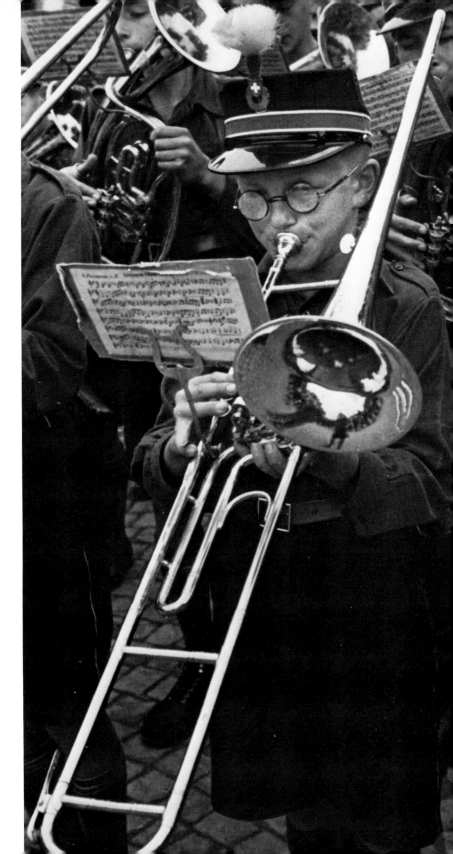

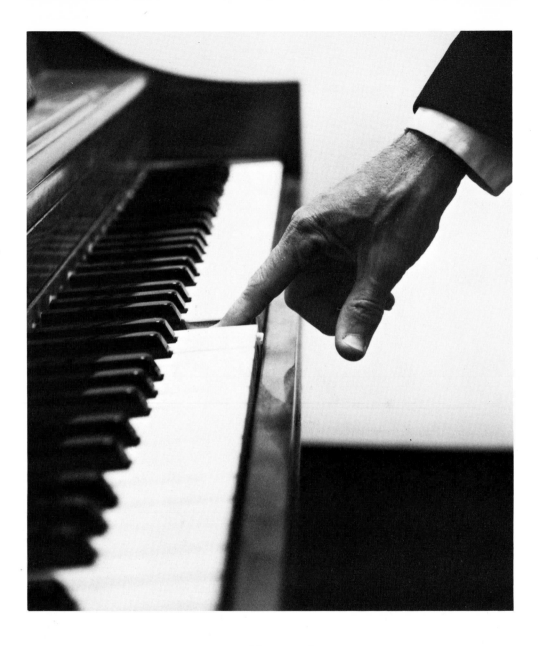

I know only two tunes;
one of them is "Yankee Doodle,"
and the other isn't.

Ulysses S. Grant (1822–1885)

Over his keys the musing organist,
 Beginning doubtfully and far away,
First lets his fingers wander as they list,
 And builds a bridge from Dreamland for his lay.

James Russell Lowell (1819–1891)

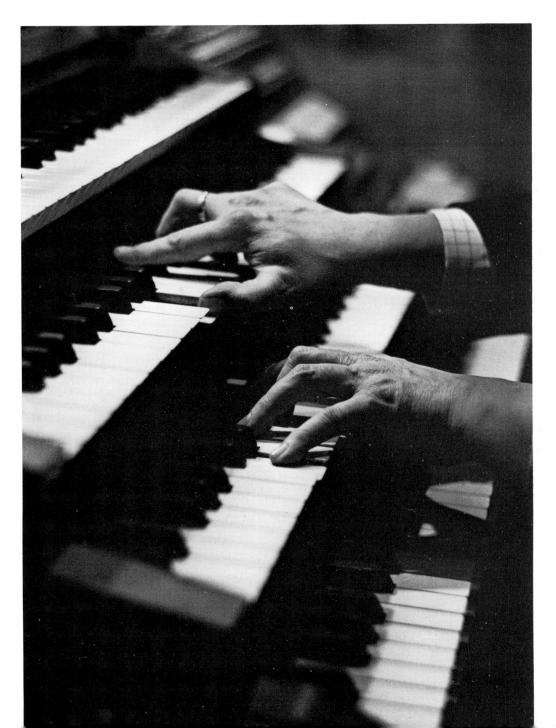

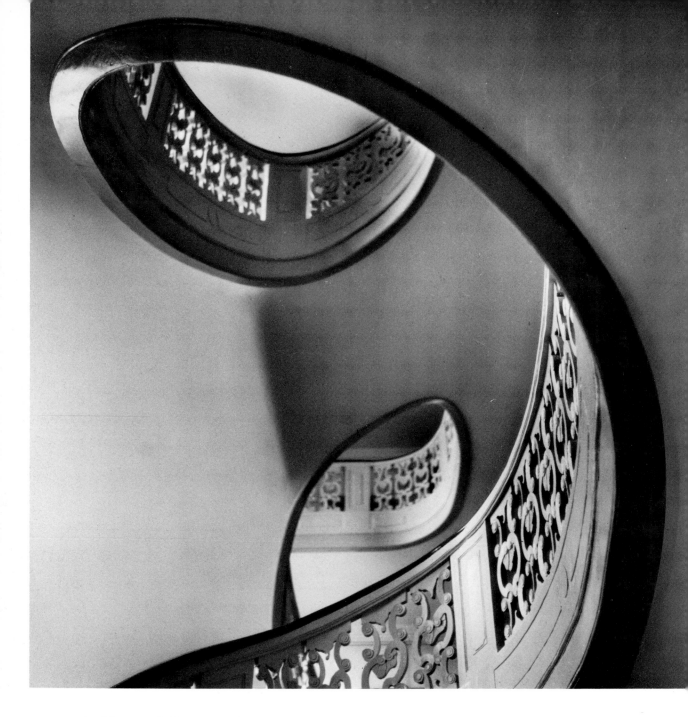

Architecture is frozen music.
 Johann Wolfgang von Goethe
 (1749–1832)

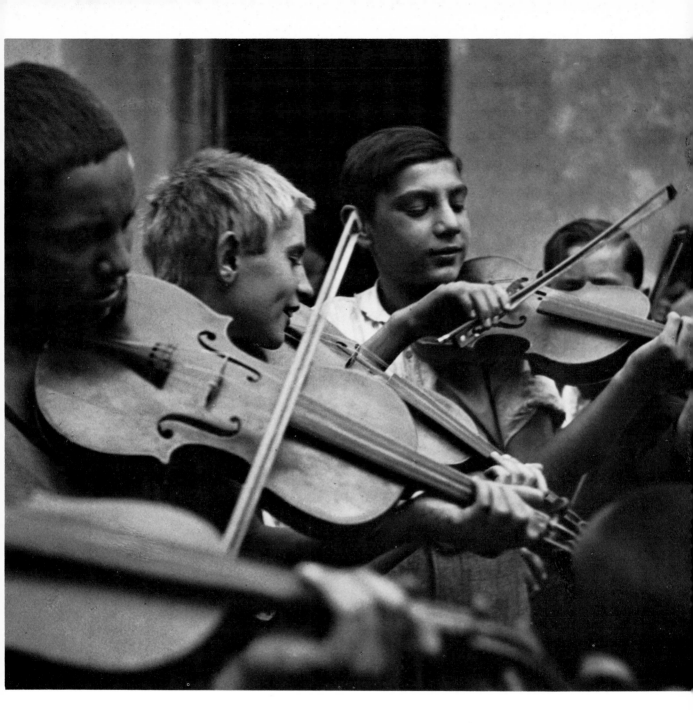

It is easier to understand a nation by listening
to its music than by learning its language.

Unknown

The double double double beat
 Of the thundering drum.
 John Dryden (1631–1700)

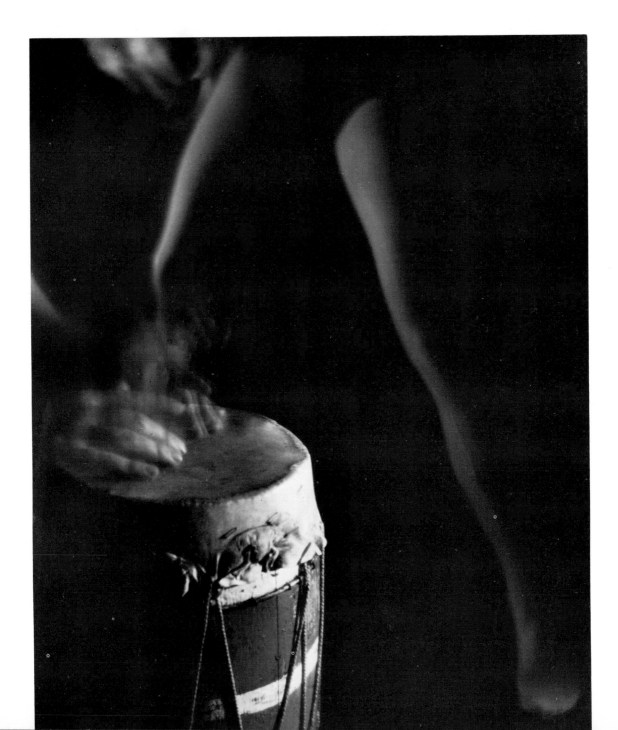

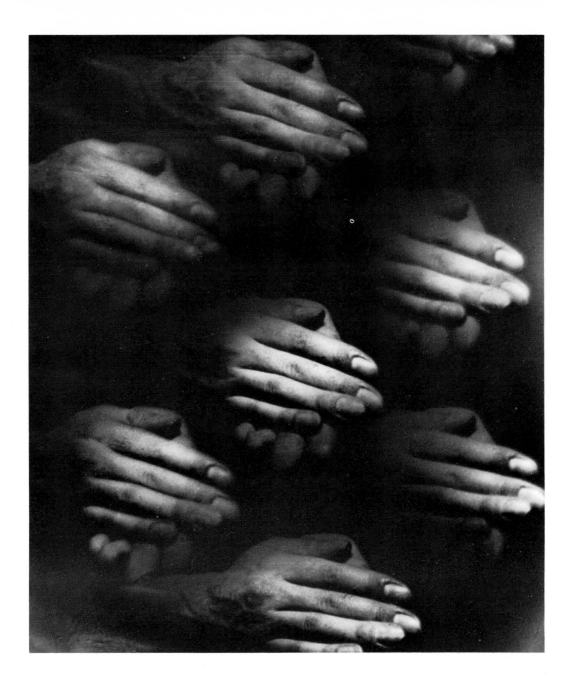

This strange beating together of hands has no meaning, and to me it is very disturbing. . . . It destroys the mood my colleagues and I have been trying to create with our music.

Leopold Stokowski

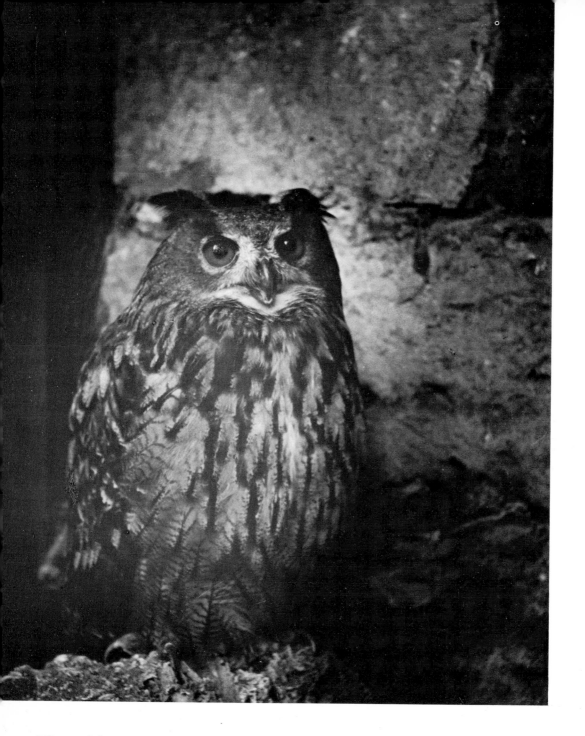

The owl has one note...
Desiderius Erasmus (1446–1536)

Not many sounds in life, and I include all urban
and rural sounds, exceed in interest a knock at the door.

Charles Lamb (1775–1834)

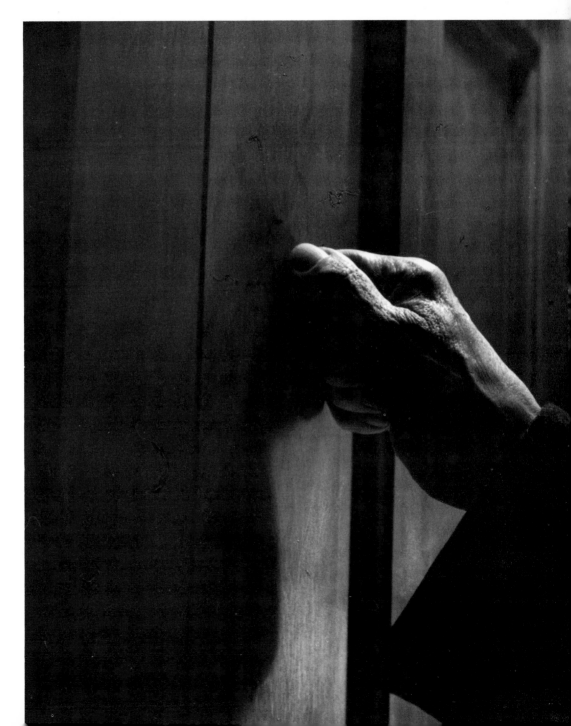

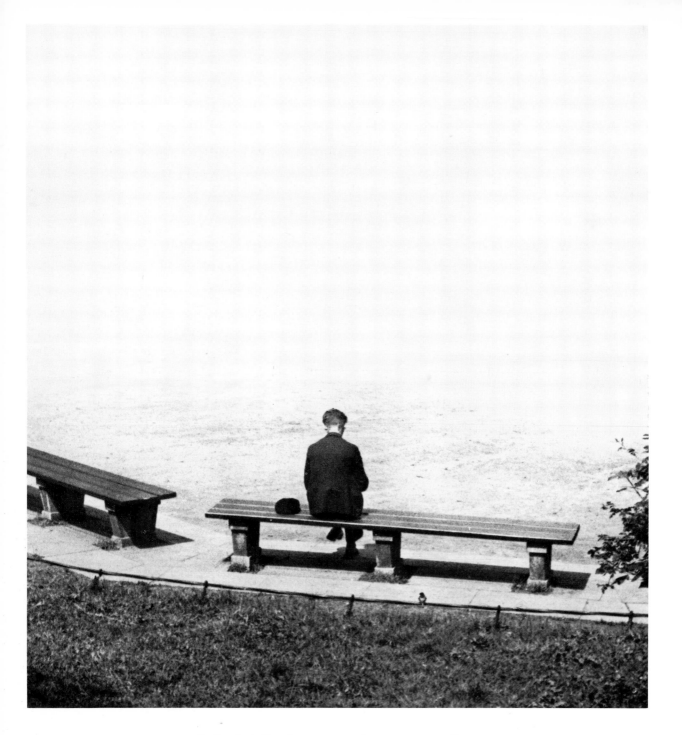

Solitude is fine but you need someone to tell you
that solitude is fine.

Honoré de Balzac (1799–1850)

Great grief...more easily
be thought than said.
Edmund Spenser (1552–1599)

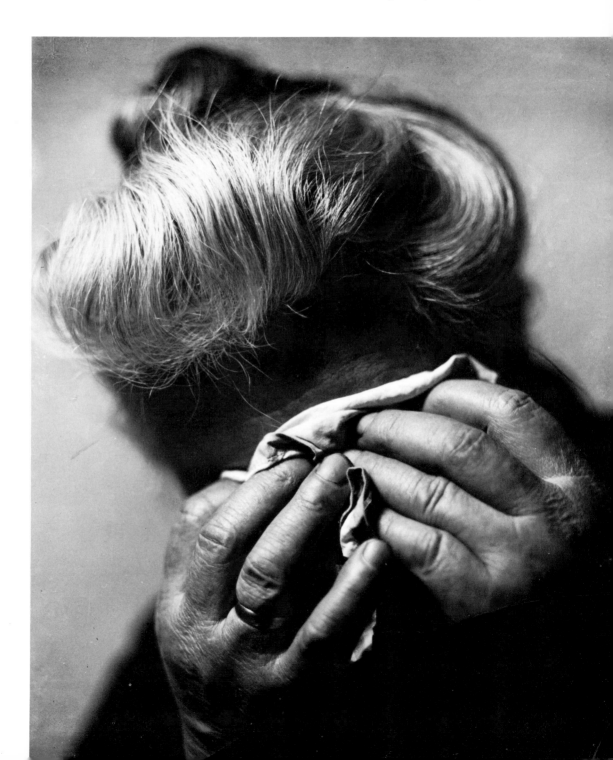

Some time an end there is
of every deed.
Geoffrey Chaucer (1340–1400)

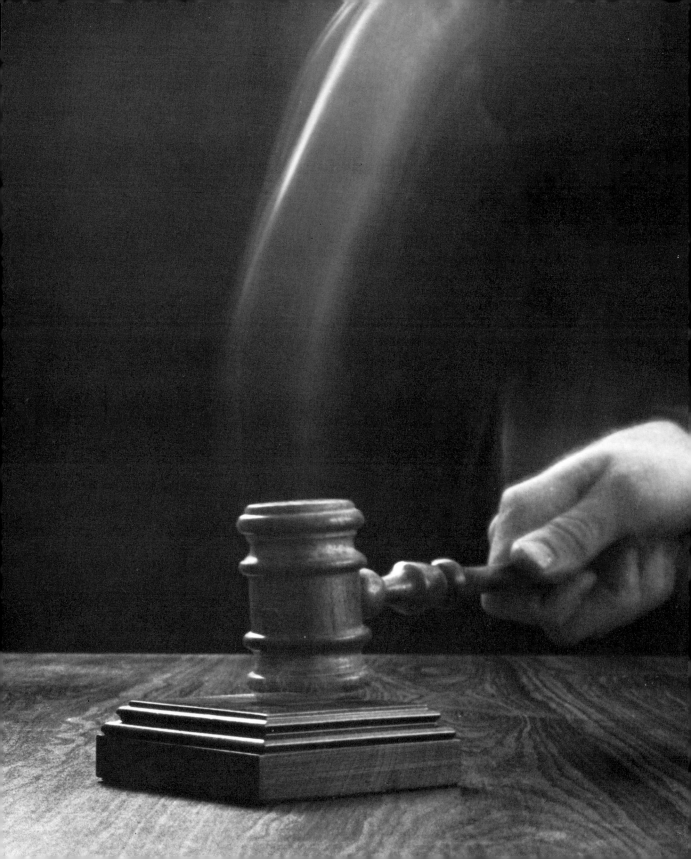

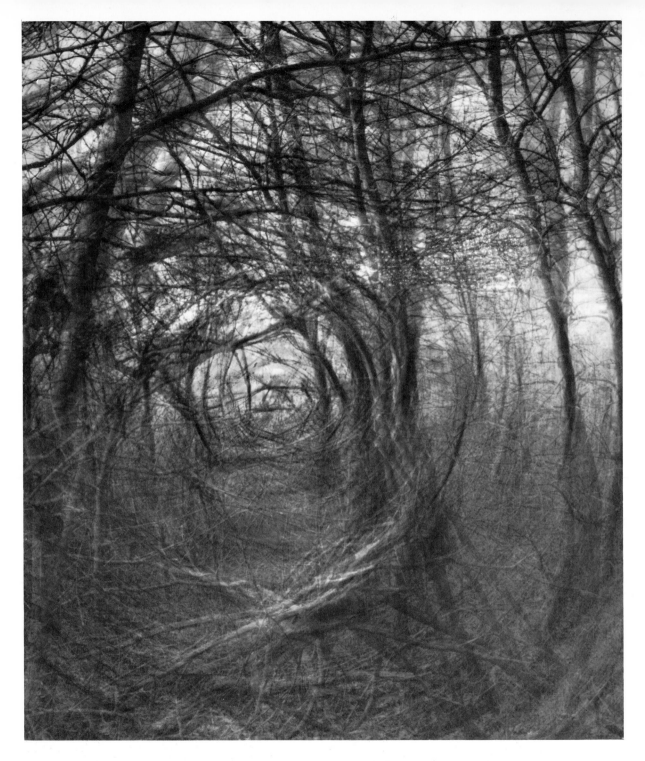

Have you heard the wind go "YO-O-O-"?
'Tis a pitiful sound to hear.

Eugene Field (1850–1895)

Ye say they all have passed away,
 That noble race and brave;
That mid the forest where they roamed
 There rings no hunter's shout;
But their name is on your waters;
 Ye may not wash it out.
 Lydia Huntley Sigourney (1791–1865)

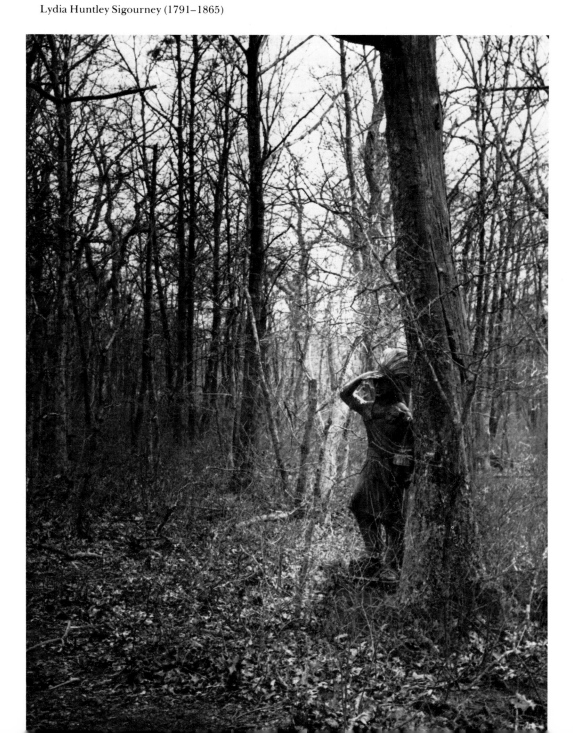

Dashing in big drops…
And making mournful music for the mind,
I hear the singing of the frequent rain.
 William H. Burleigh (1812–1871)

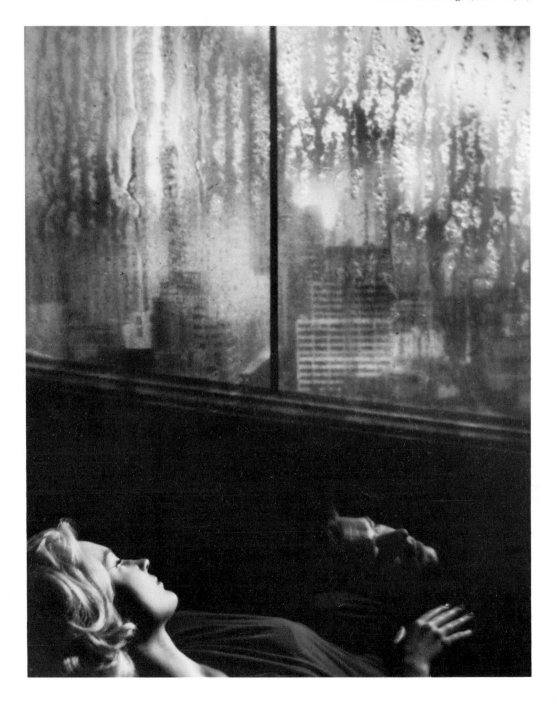

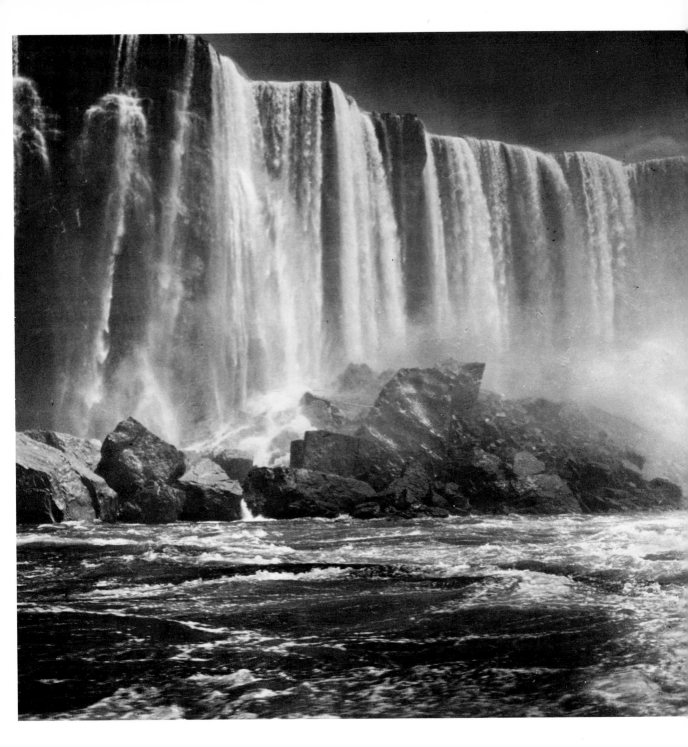

No rest for Niagara, but perpetual ran-tan on those limestone rocks.

Henry David Thoreau (1817–1862)

A little noiseless noise
among the leaves...
John Keats (1795–1821)

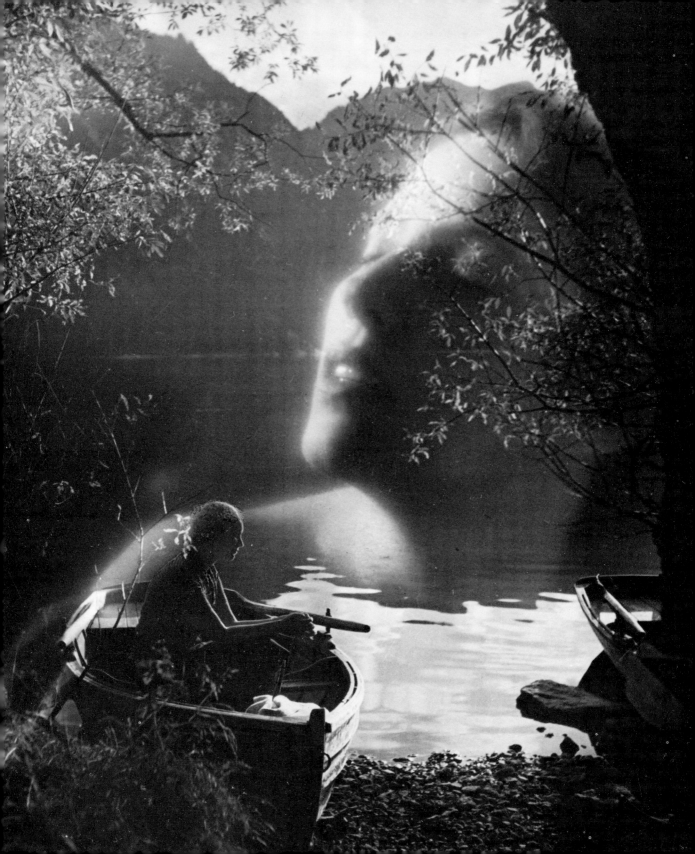

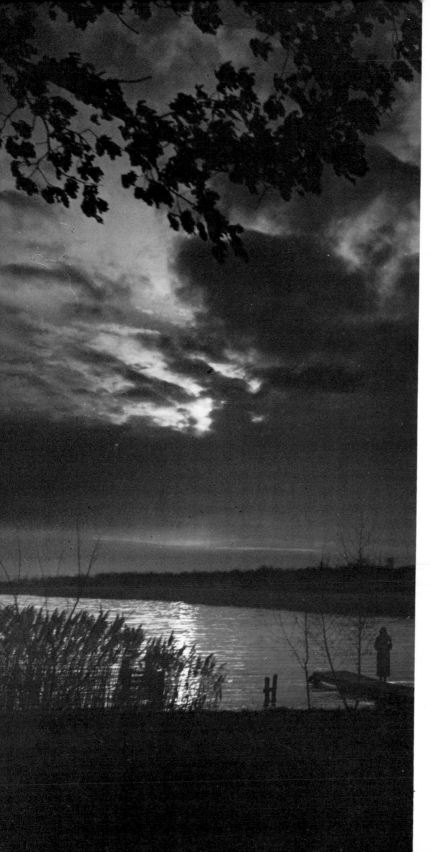

Silence, like poultice,
comes to heal the blows
of sound.

Oliver Wendell Holmes
(1809–1894)

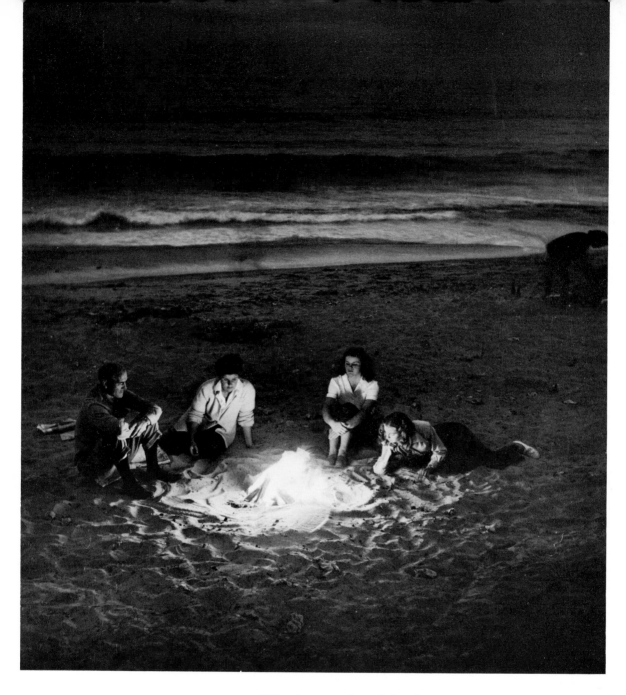

What is more cheerful...then an open-woodfire?...
Those little chirps and twitters
coming out of that piece of apple-wood
...are the ghosts of the robins
and blue-birds that sang upon the bough
when it was in bloosom.

Thomas Bailey Aldrich (1836–1907)

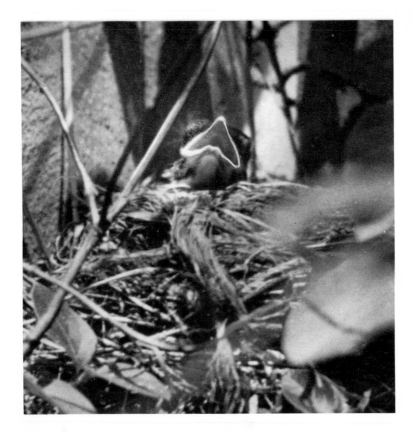

A still small voice...
 Old Testament

I thought the sparrow's note from heaven...
 I brought him home...but it cheers not now,
For I did not bring home the river and sky.
 Ralph Waldo Emerson (1803–1882)

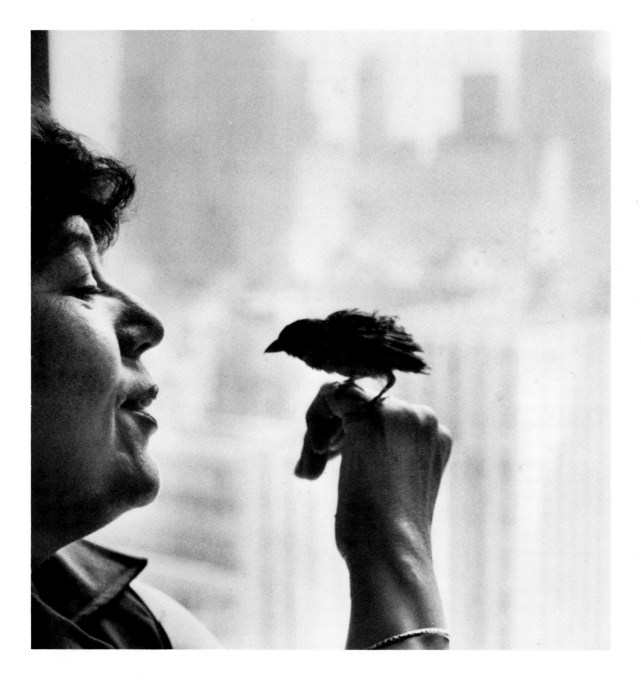

It makes all the difference whether you hear an insect in the bedroom or in the garden.

Robert Lynd (1879–1949)

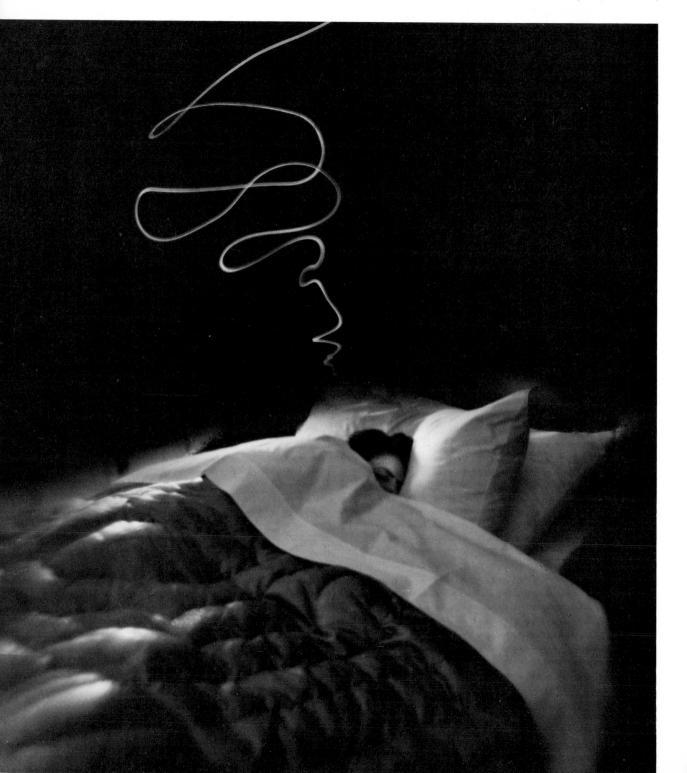

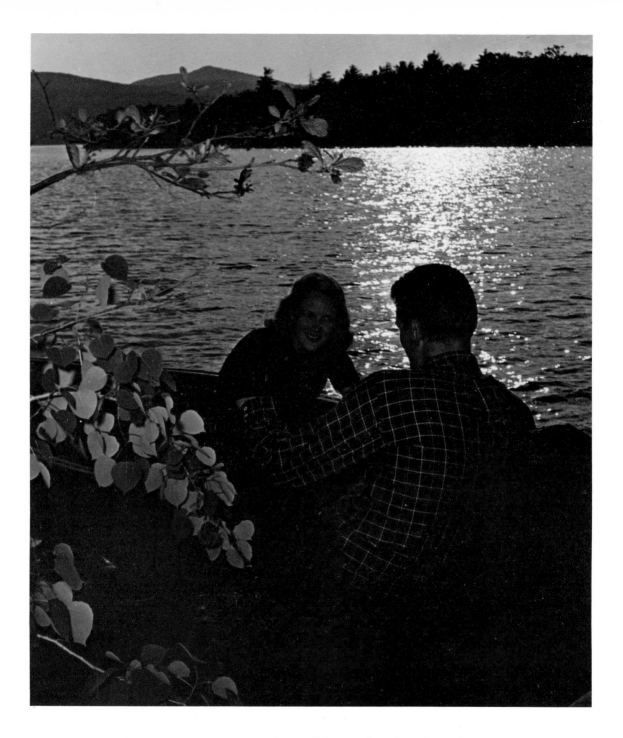

They spake winged words
one to another.

Homer (*ca.* 850 B.C.)

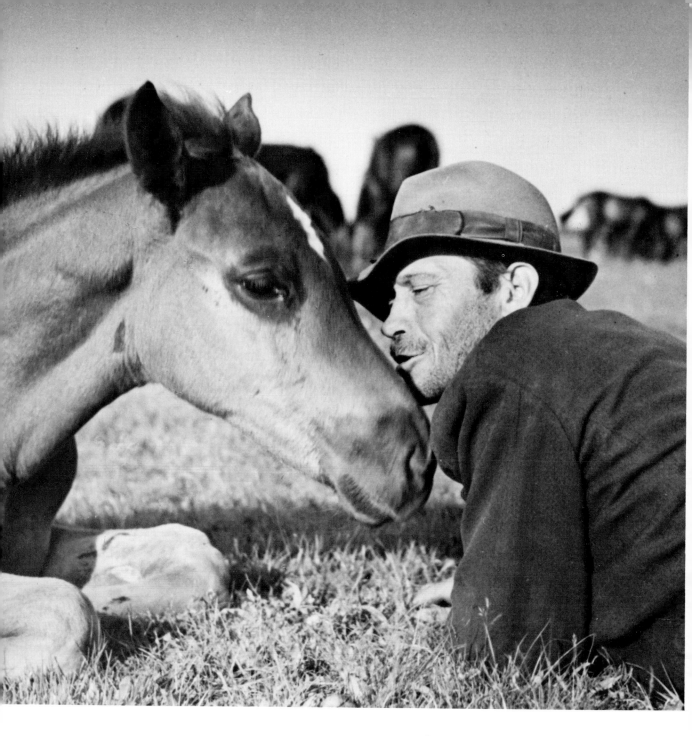

The best kind of conversation is that
which may be called thinking aloud.

William Hazlitt (1778–1830)

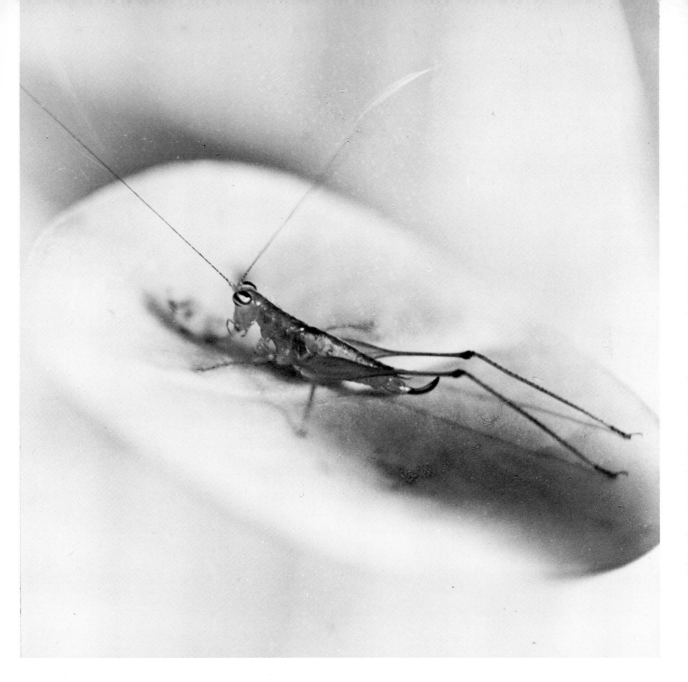

I want live things in their pride to remain,
I will not kill one grasshopper vain
Though he eats a hole in my shirt like a door.
I let him out, give him one chance more.
Perhaps, while he gnaws my hat in his whim,
Grasshopper lyrics occur to him.

Vachel Lindsay (1879–1931)

The wheel that does the squeaking
is the one that gets the grease.

Proverb

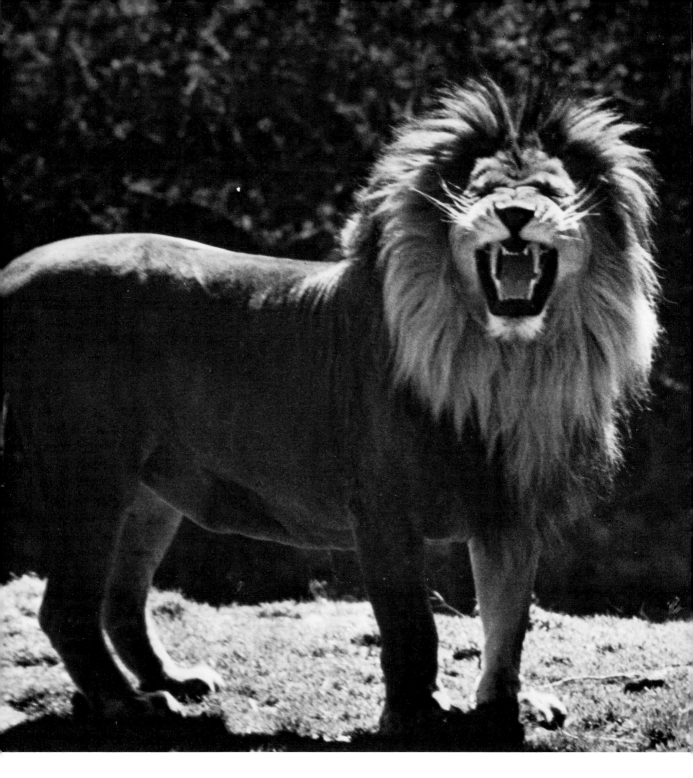

That roar, the prowling lion's HERE I AM.
William Wordsworth (1770–1850)

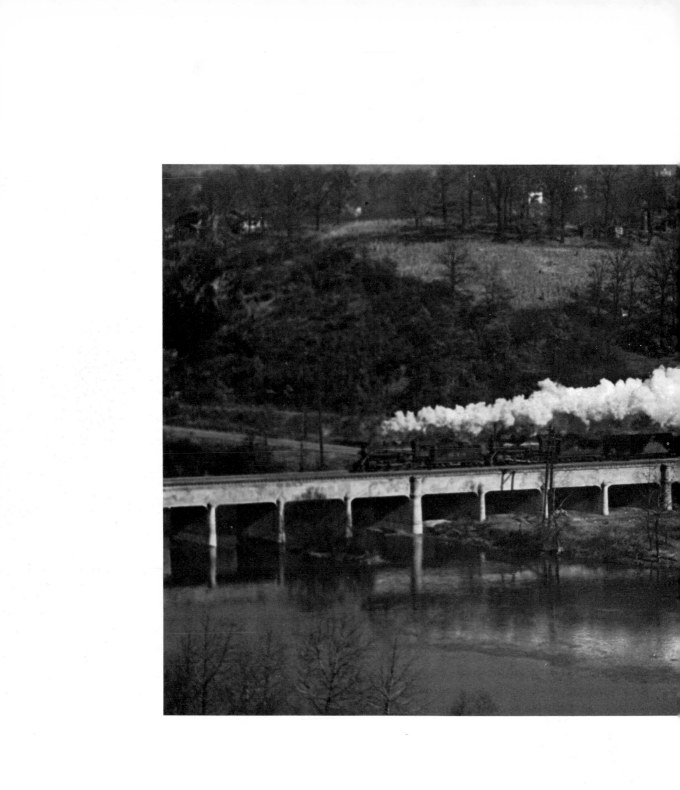

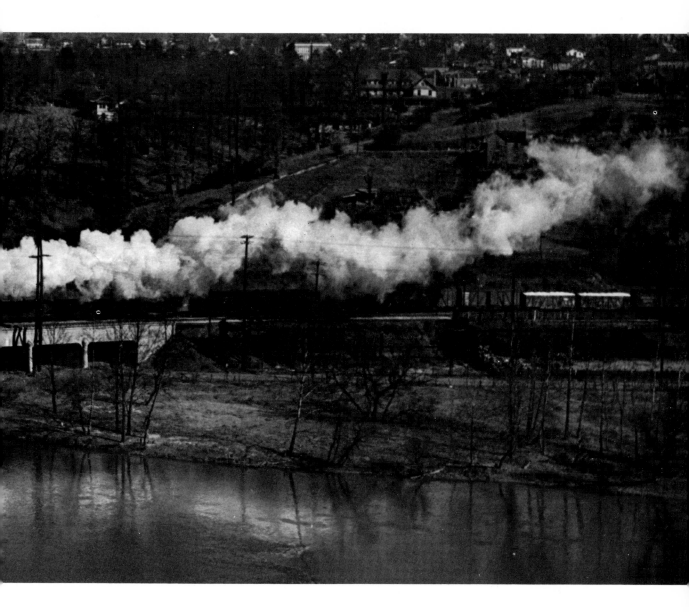

Far out beyond that timeless valley, a train...
wailed back its ghostly cry...

Thomas Wolfe (1900–1938)

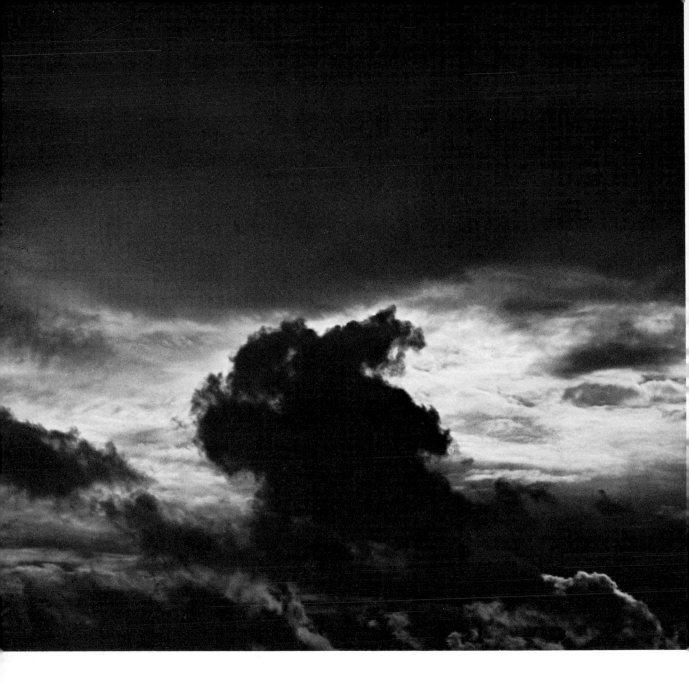

And hark to the crashing, long and loud,
Of the chariot of God, in the thunder-cloud!

William Cullen Bryant (1794–1878)

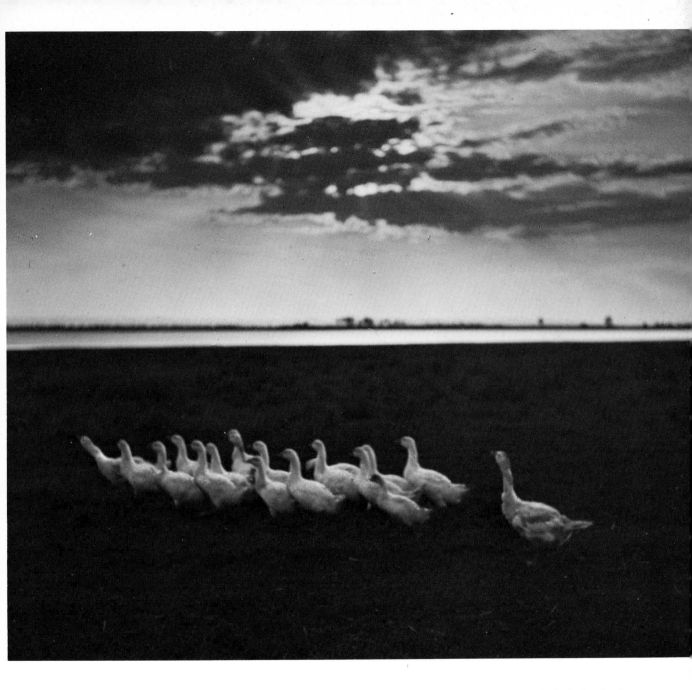

...rob Rome's ancient geese of all their glories,
And cackling save the monarchies of Tories.

Alexander Pope (1688–1744)

(geese saved Rome; their loud cackling warned the Romans,
when the enemy approached the city)

A footstep, a low throbbing in the walls,
A noise of falling weights that never fell,
Weird whispers, bells that rang without a hand,
Door-handles turn'd when none was at the door,
and bolted doors that open'd of themselves.

Alfred Tennyson (1809–1892)

A hurry of hoofs in a village street,
A shape in the moonlight, a bulk in the dark...
...a steed flying fearless and fleet.
Henry Wadsworth Longfellow (1807–1882)

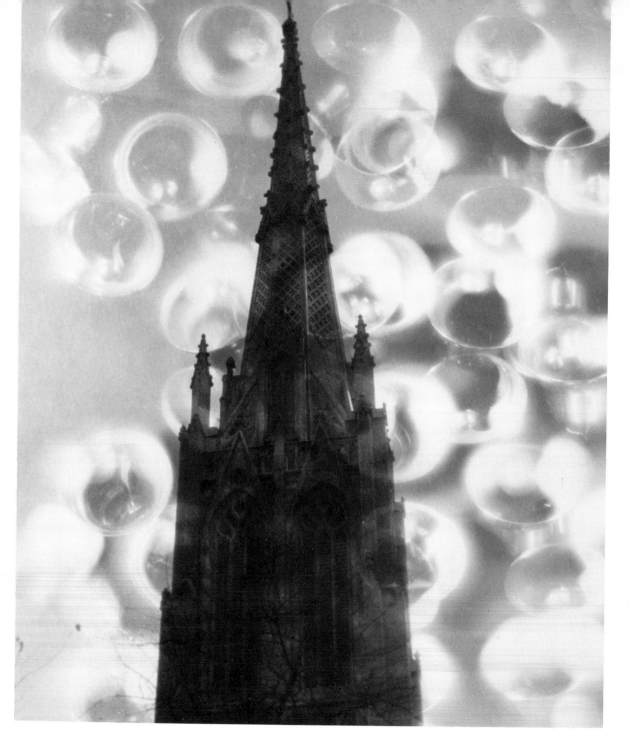

Silver bells!
What a world of merriment their melody foretells!
How they tinkle, tinkle, tinkle,
In the icy air of night!

Edgar Allan Poe (1809–1849)

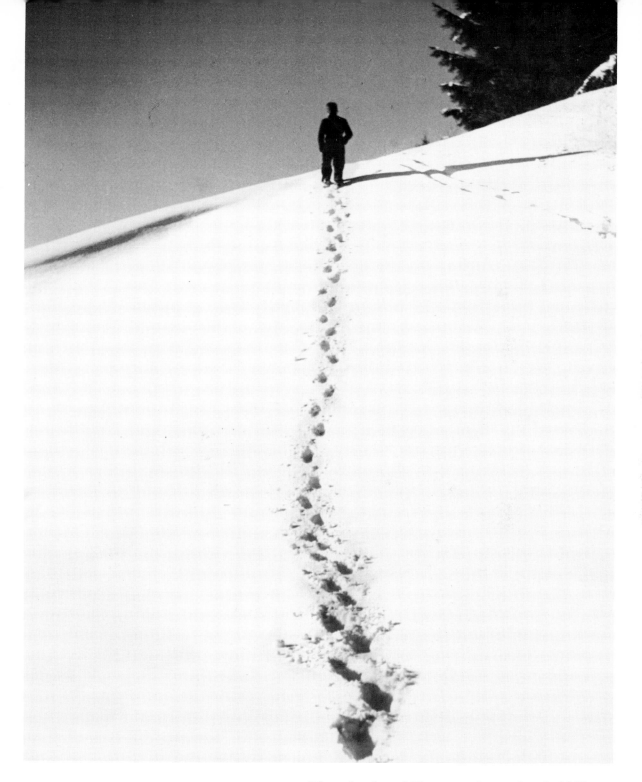

The splendor of Silence,—of snow-jeweled hills and of ice.

Ingram Crockett

Life buzzed slowly like a fly....
A wagon rattled leanly
over the big cobbles.
Thomas Wolfe (1900–1938)

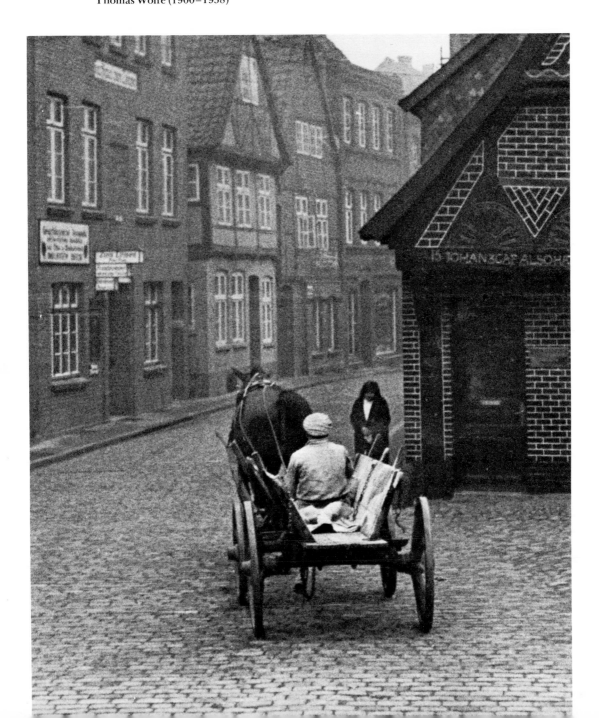

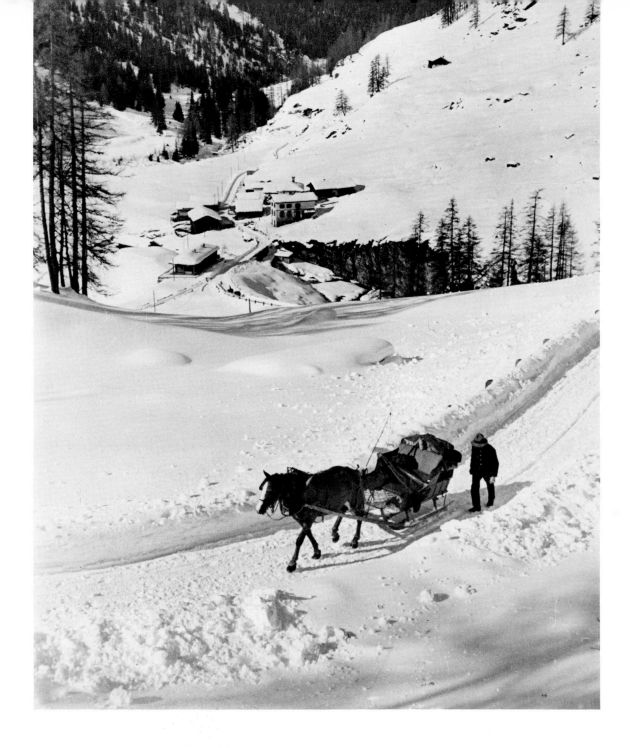

Stern Winter loves a dirge-like sound.

William Wordsworth (1770–1850)

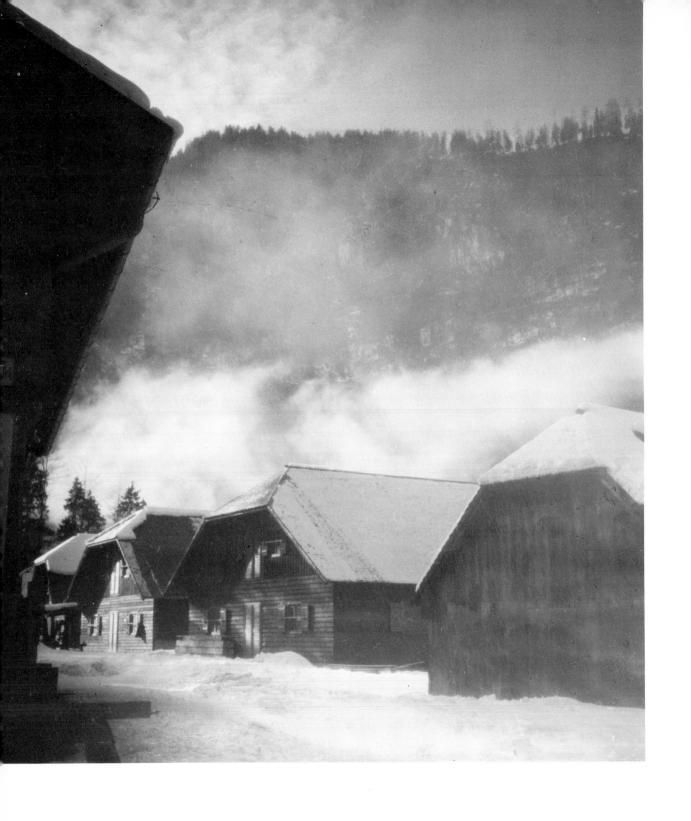

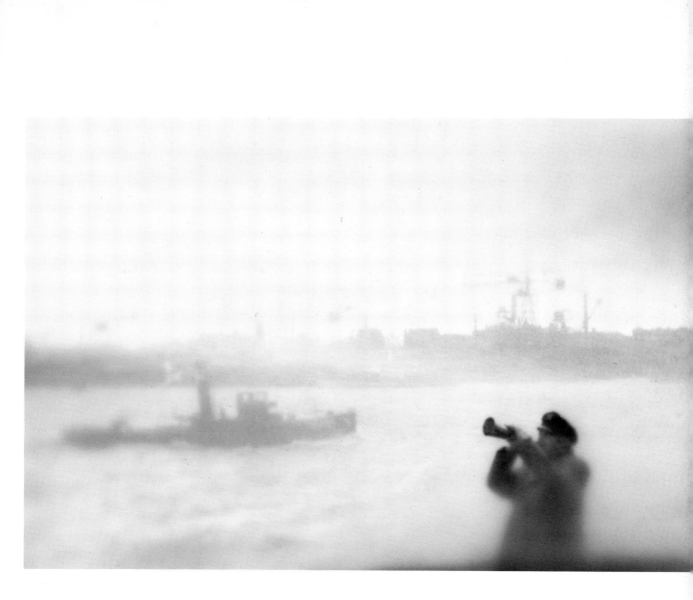

One day many years ago a man walked along and stood in the sound of the ocean on a cold sunless shore and said, "We need a voice to call across the water, to warn ships; I'll make one.... I'll make a sound that's so alone that no one can miss it.... I'll make me a sound and an apparatus and they'll call it a Fog Horn."

Ray Bradbury

What are fears but voices airy?
Whispering harm where harm is not...
William Wordsworth (1770–1850)

When awful darkness and silence reign...
Through the long, long wintry nights.
<div style="text-align: right;">Edward Lear (1812–1888)</div>

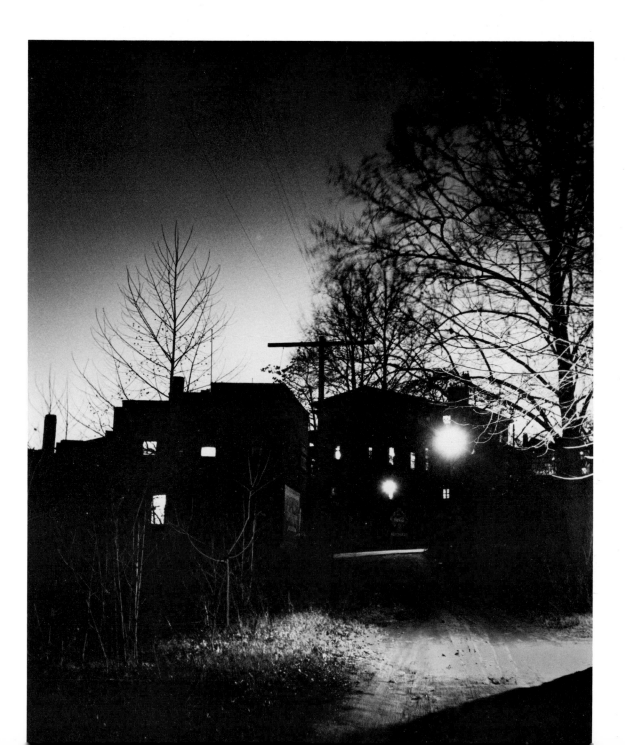

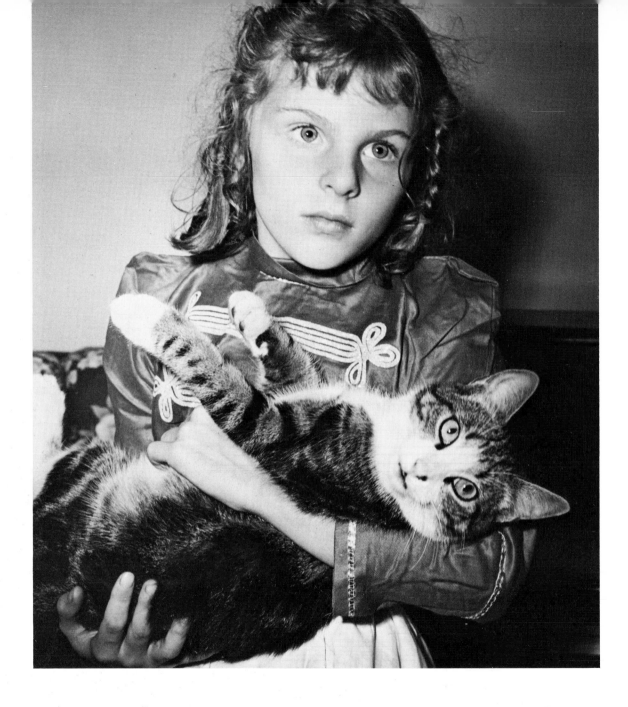

Eyes can speak and eyes can understand.
George Chapman (1559–1634)

Often a silent face has voice and words.
Ovid (43 B.C.–A.D. 17)

Children should be seen
and not heard.

English proverb

Sweet Benjamin, since thou art young,
and hast not yet the use of tongue,
Make it thy slave, while thou art free;
Imprison it, lest it do thee.

John Hoskins (1566–1638)

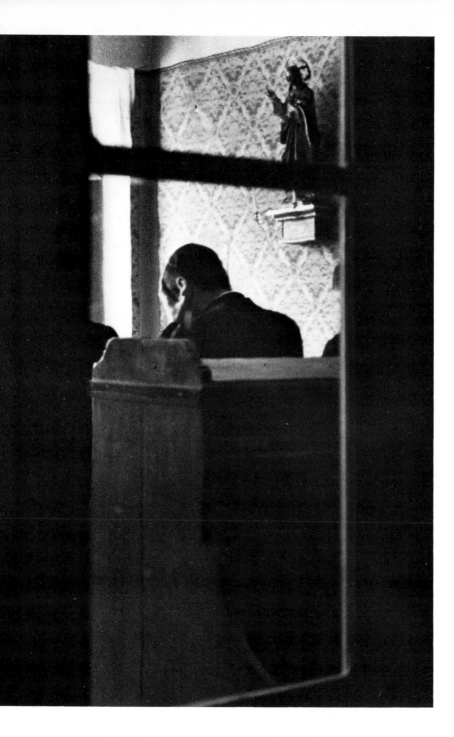

Their eldest son was such a disappointment to them; they wanted him to be a linguist, and spent no end of money on having him taught to speak—oh, dozens of languages!—and then he became a Trappist monk.

Saki (1870–1916)

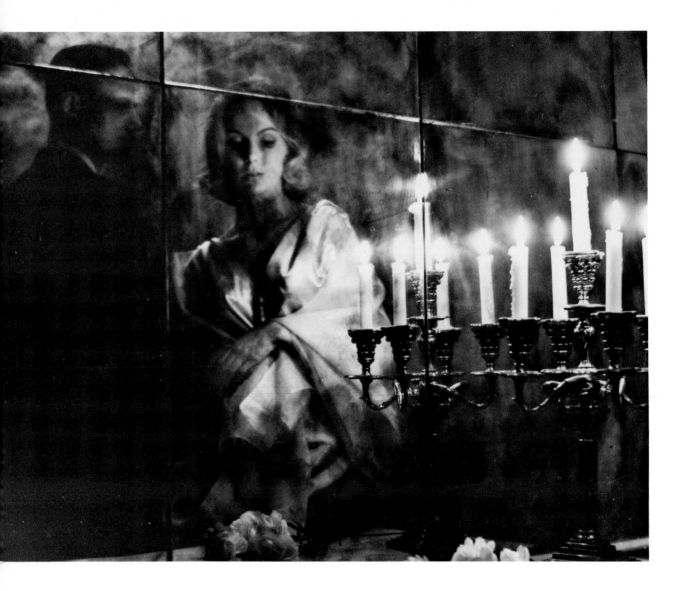

To use silence in time and place
passeth all well speaking

Stefano Guazzo (1530–1593)

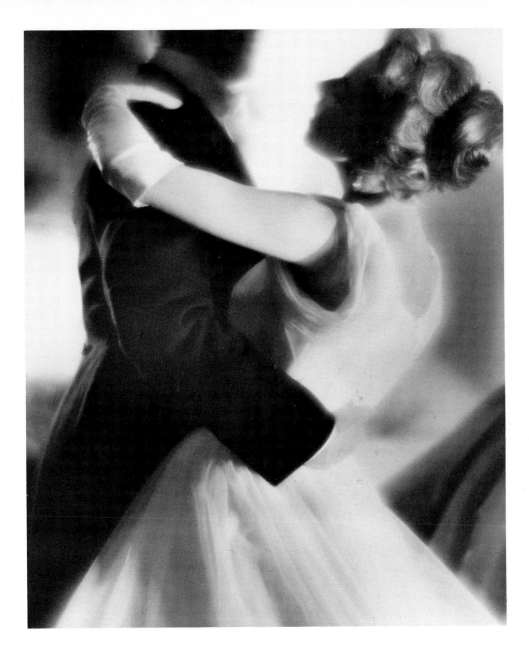

All who take part in a waltz or cotillion
Are mounted for hell on the devil's own pillion,
Who, as every true orthodox Christian well knows,
Approaches the heart through the door of the toes.

James Russell Lowell (1819–1891)

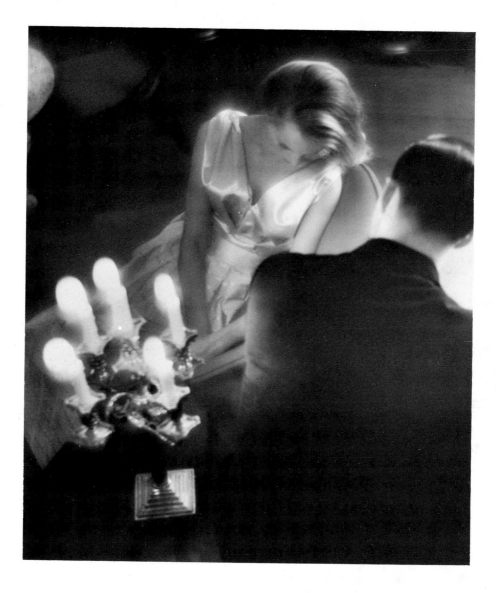

What cannot a neat knave with a smooth tale
Make a woman believe?

John Webster (1580–1625)

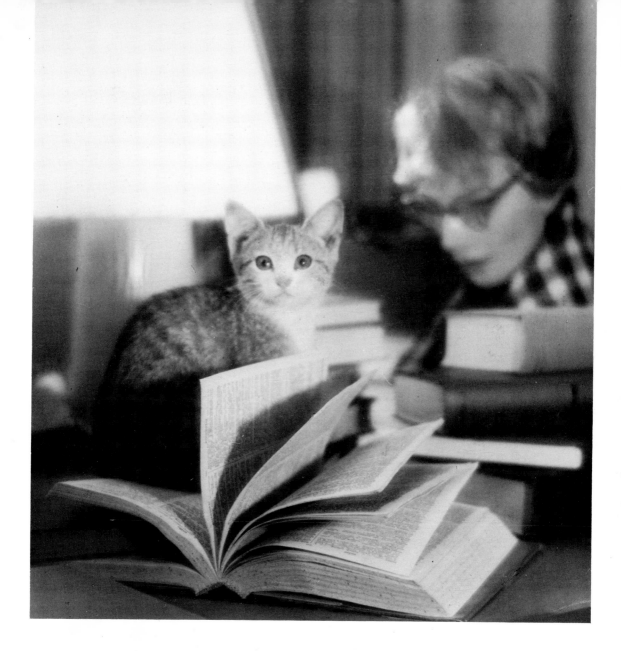

I hate a woman...who observes all the rules and laws of language, who quotes from ancient poets that I never heard of, and corrects her unlettered friends for slips of speech that no man need trouble about: let husbands at least be permitted to make slips in grammar!

Juvenal (60–140)

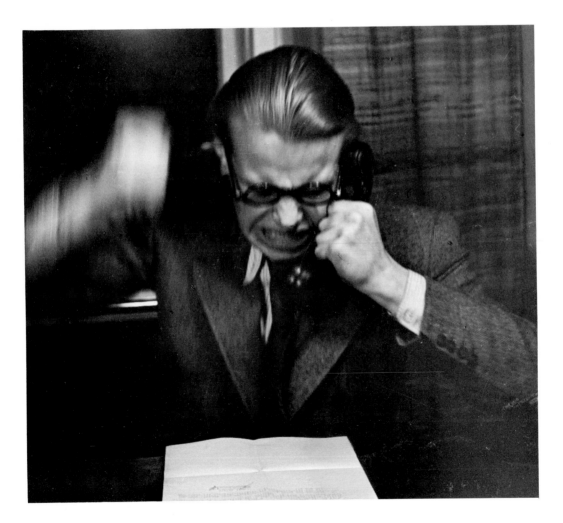

Oppose not rage while rage is in its force,
but give it way a while and let it waste.

William Shakespeare (1564–1616)

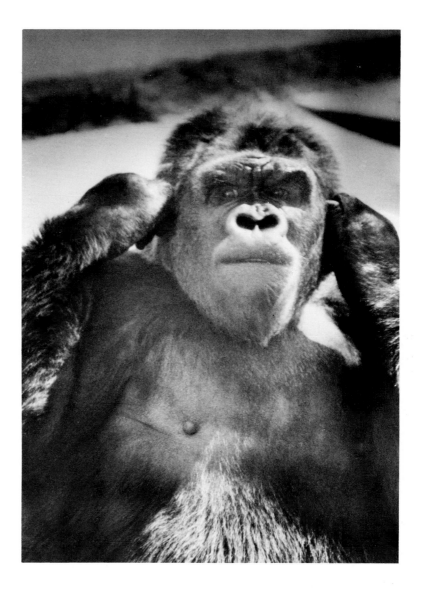

What a mercy it would be if we were able
to open and close our ears as easily
as we open and close our eyes!

G.C. Lichtenberg (1742–1799)

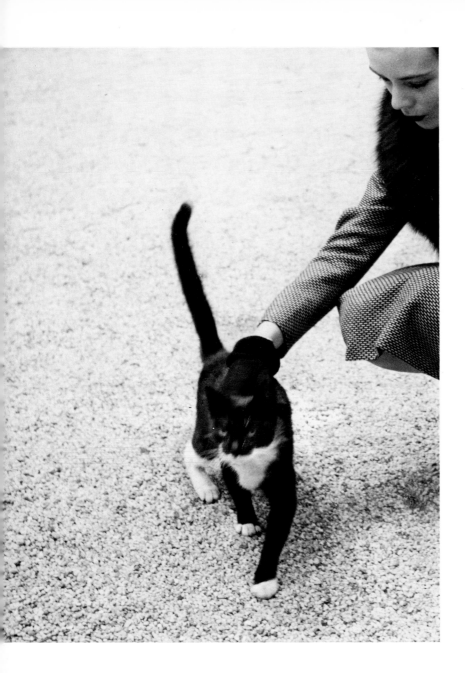

Her conscious tail her joy declared:
The fair round face, the snowy beard,
 The velvet of her paws...
Her ears of jet, and emerald eyes,
 She saw, and purr'd applause.

Thomas Gray (1716–1771)

To catch a squirrel
make a noise like a nut.
Honoré de Balzac
(1799–1850)

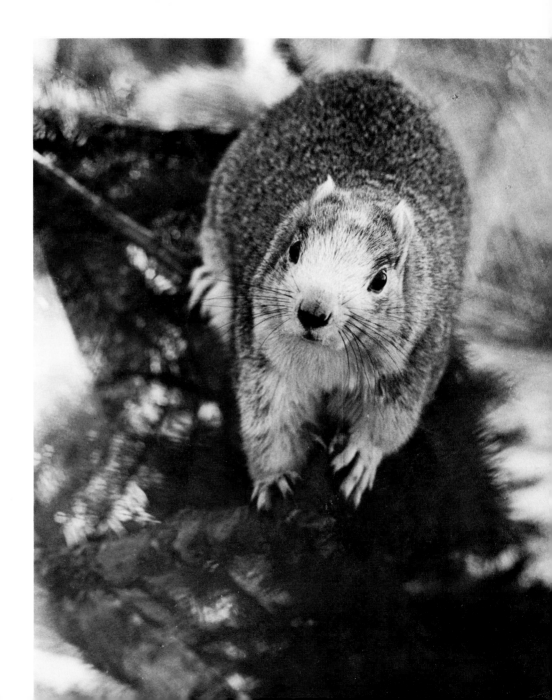

A good laugh is sunshine in the house.
William M. Thackeray (1811–1863)

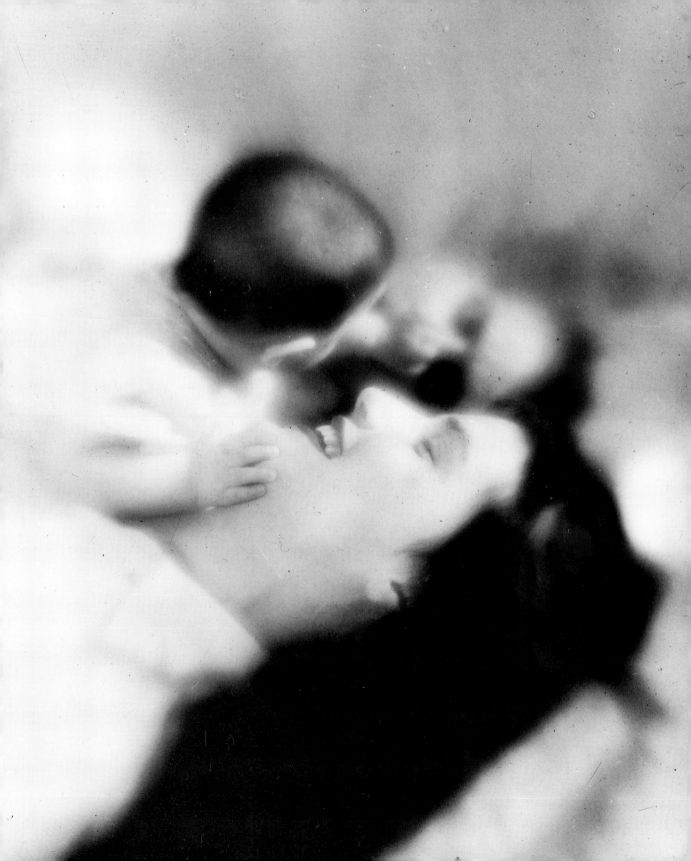